Color Your Heart with Love

Copywrite 2019 by Marilynn Methven

This book is printed as it is ordered, so there is no waste.
The ink is chlorine-free, and the interior paper stock is acid-free.

Best use for coloring will be colored pencils and crayon type pencils. Markers may bleed through to the next page.

Feel free to follow my author page on Amazon. ♡

www.amazon.com/author/marilynnmethven

LOVE IS FRIENDSHIP SET TO MUSIC.

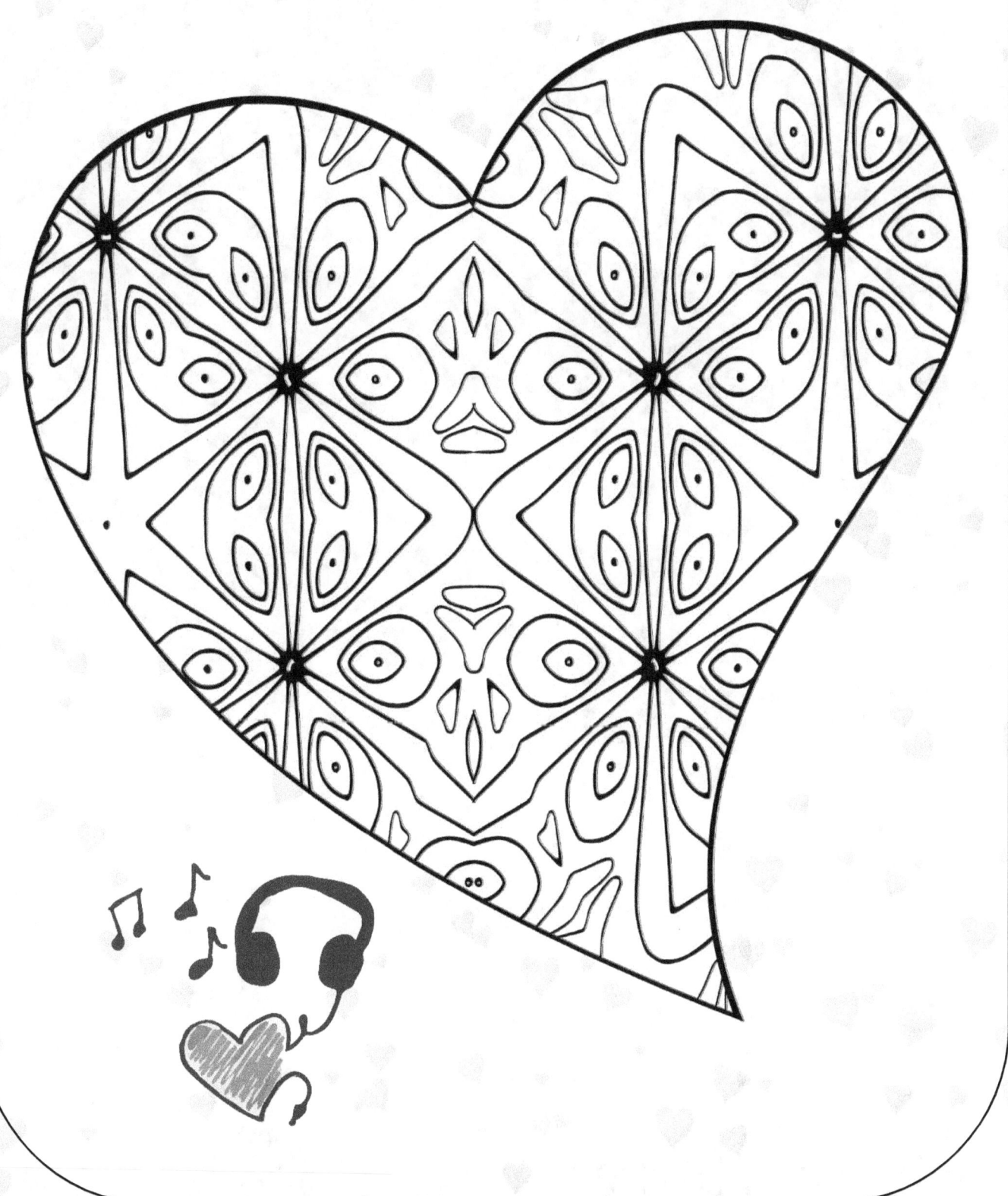

YOU ARE MY JOY, MY WORLD, MY HEART.

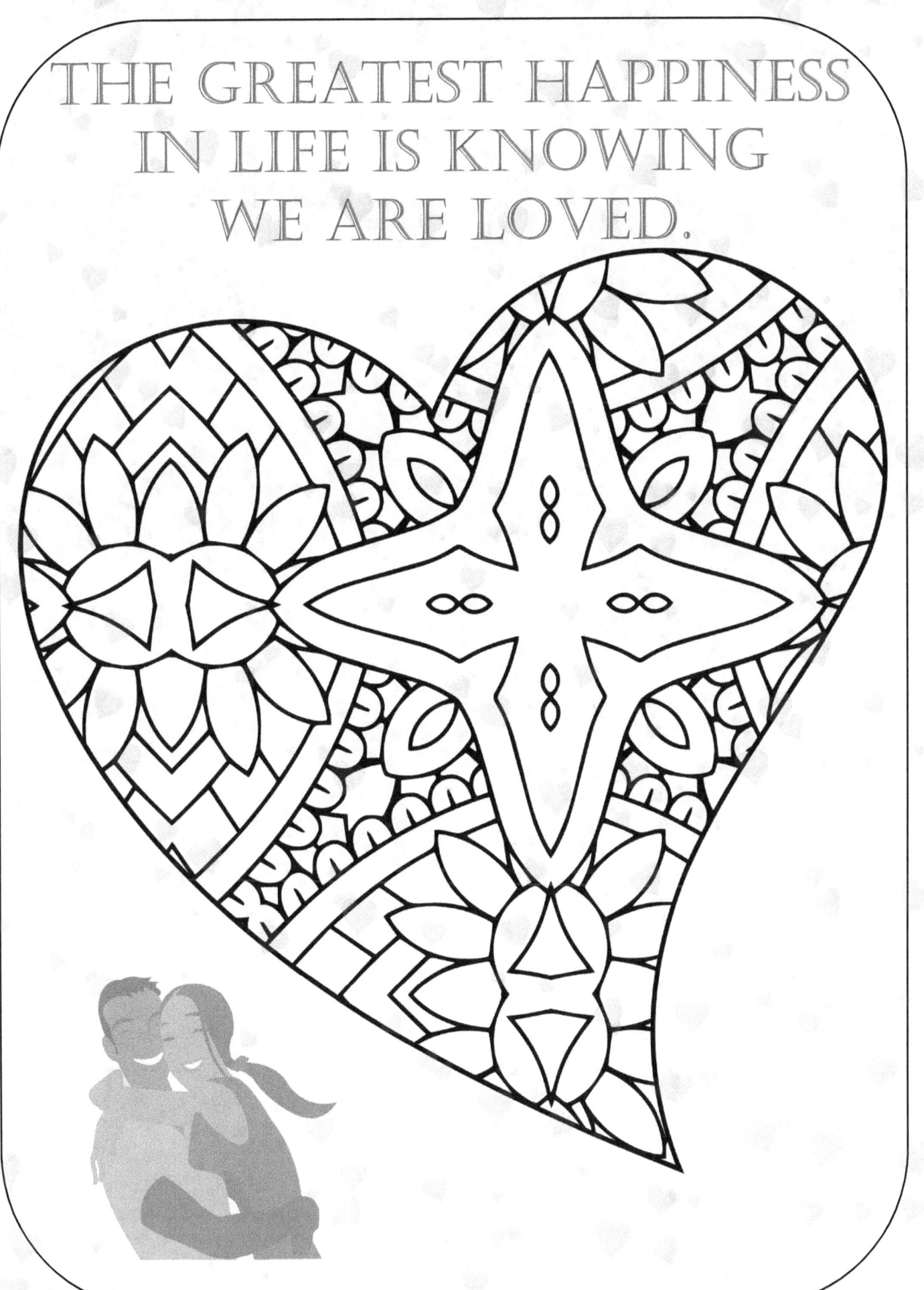

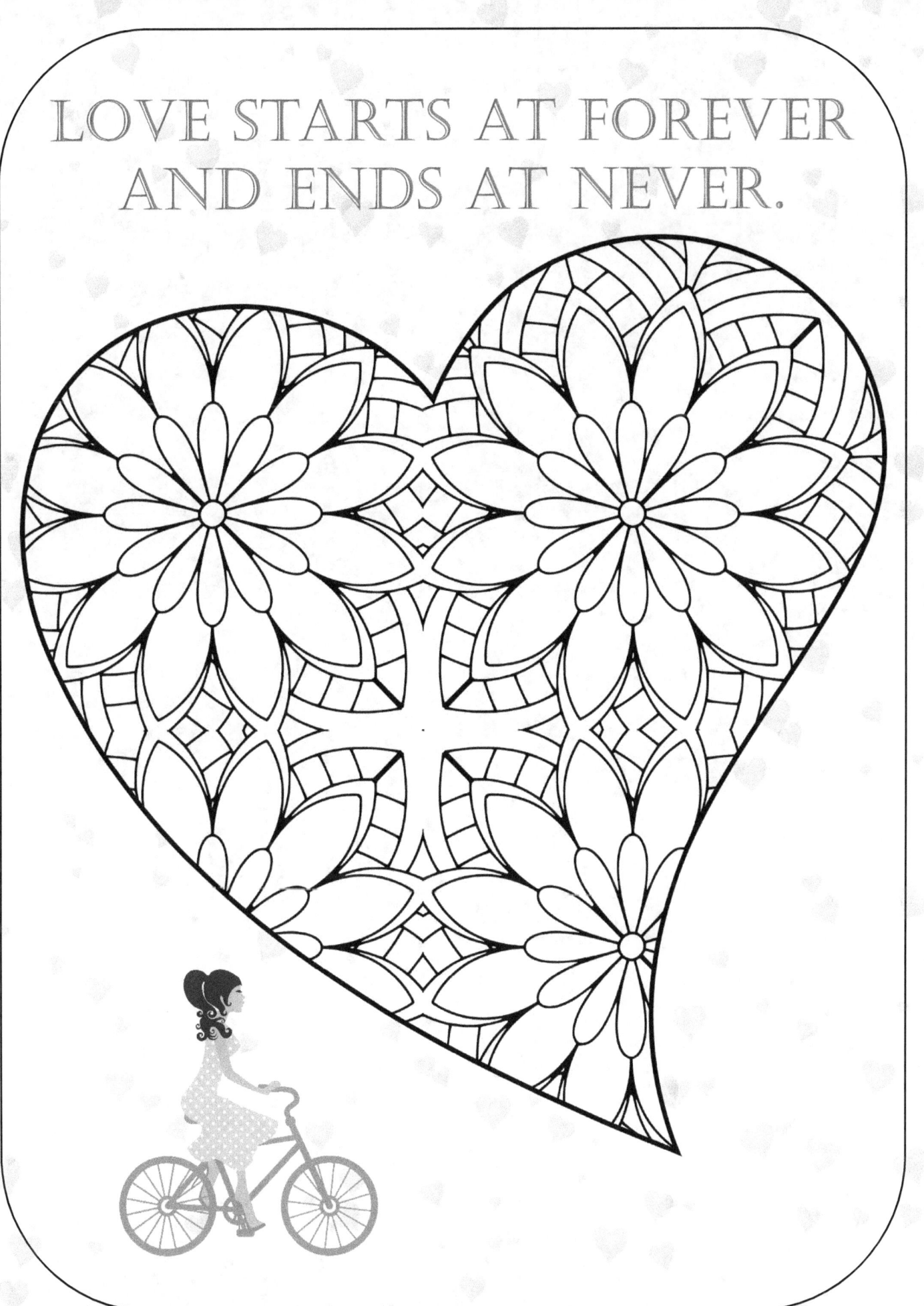

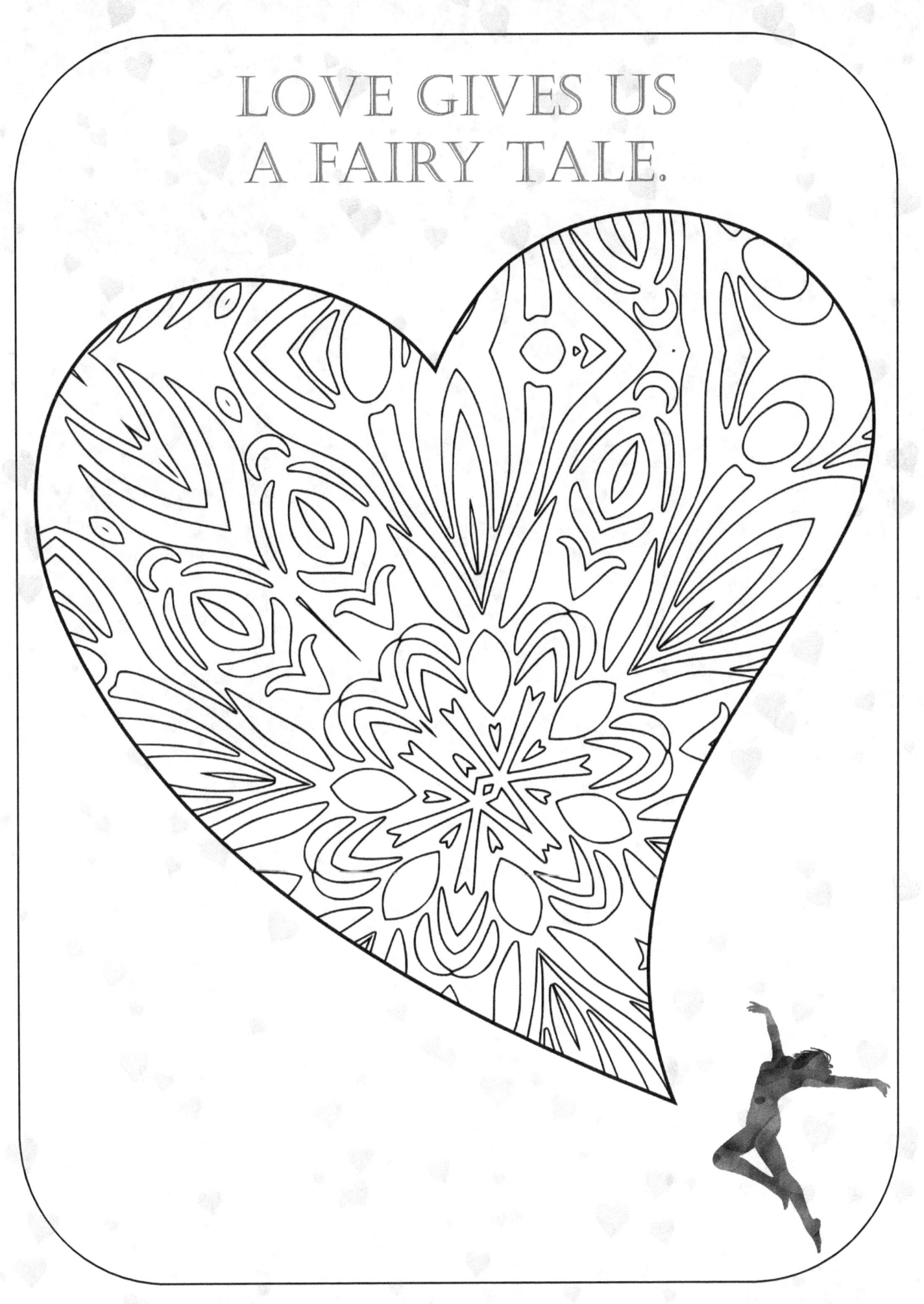

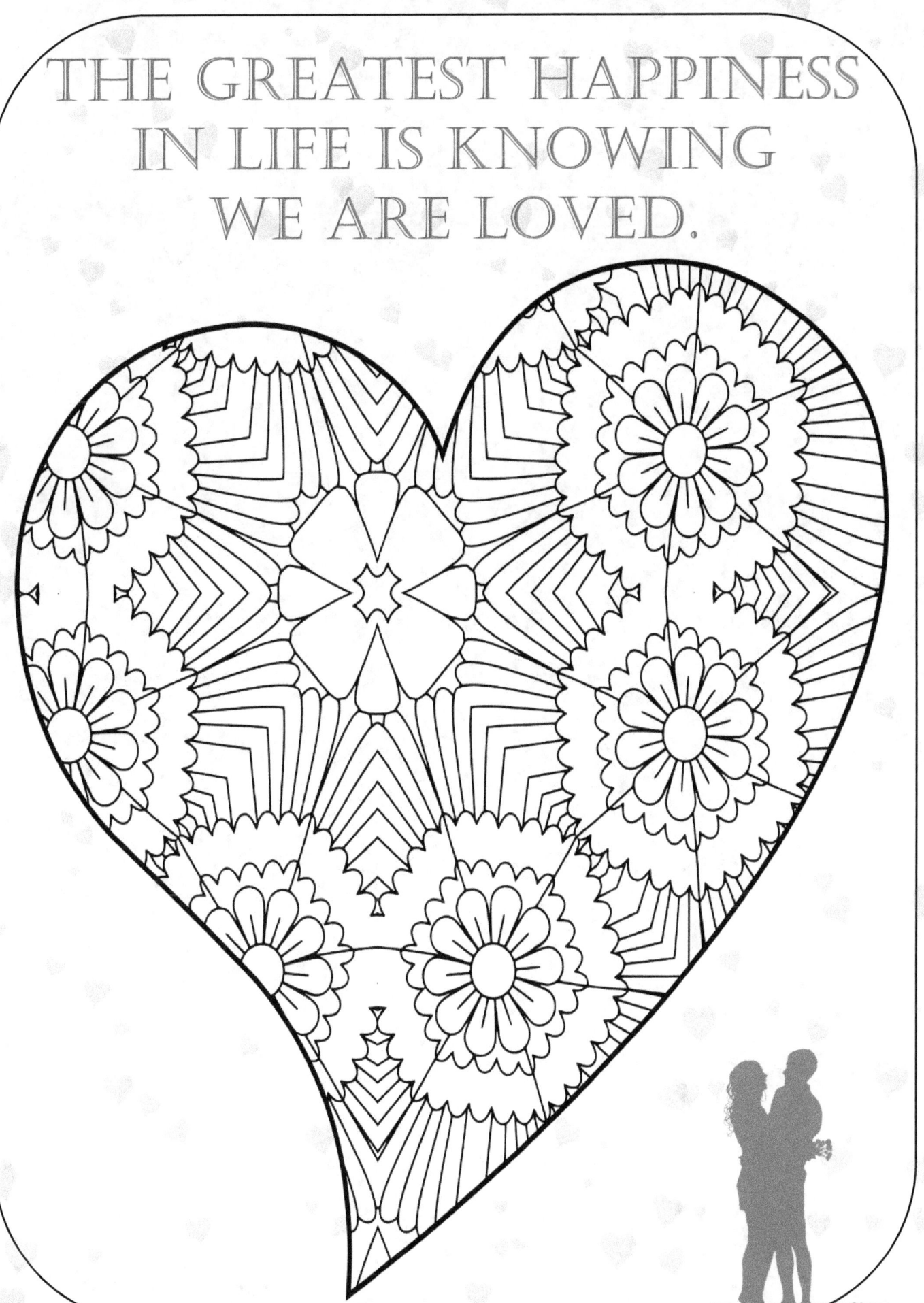

LETS BUILD A CASTLE WITH LOVE AS THE FOUNDATION.

LOVE SINGS A SONG ONLY YOU CAN HEAR.

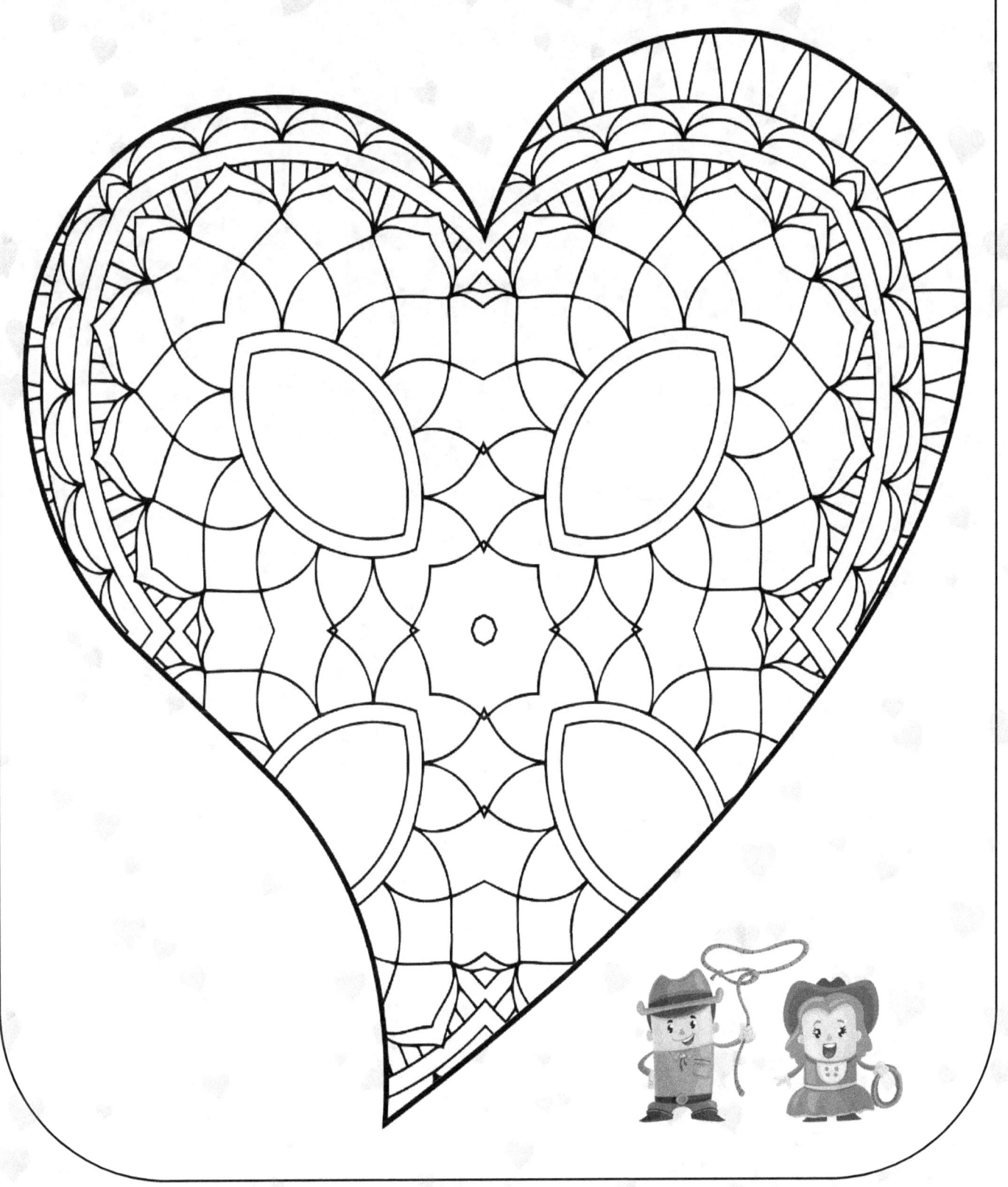

COME, MY LOVE, LIVE IN MY HEART.

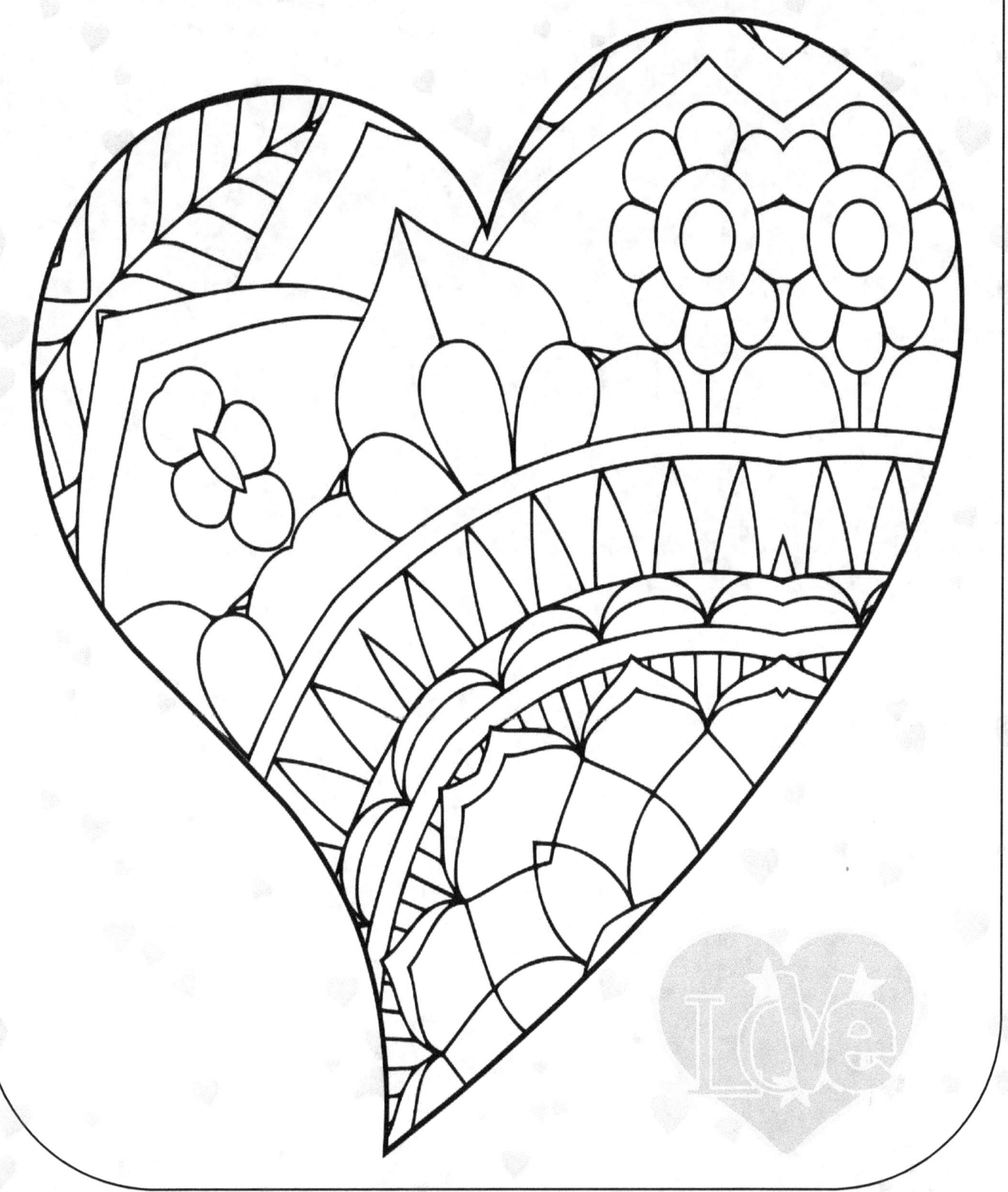

I WILL LOVE YOU UNTIL THE STARS GO DARK.

YOU MAKE MY CARDIAC MUSCLE PUMP BLOOD QUICKLY THROUGH MY VASCULAR SYSTEM.

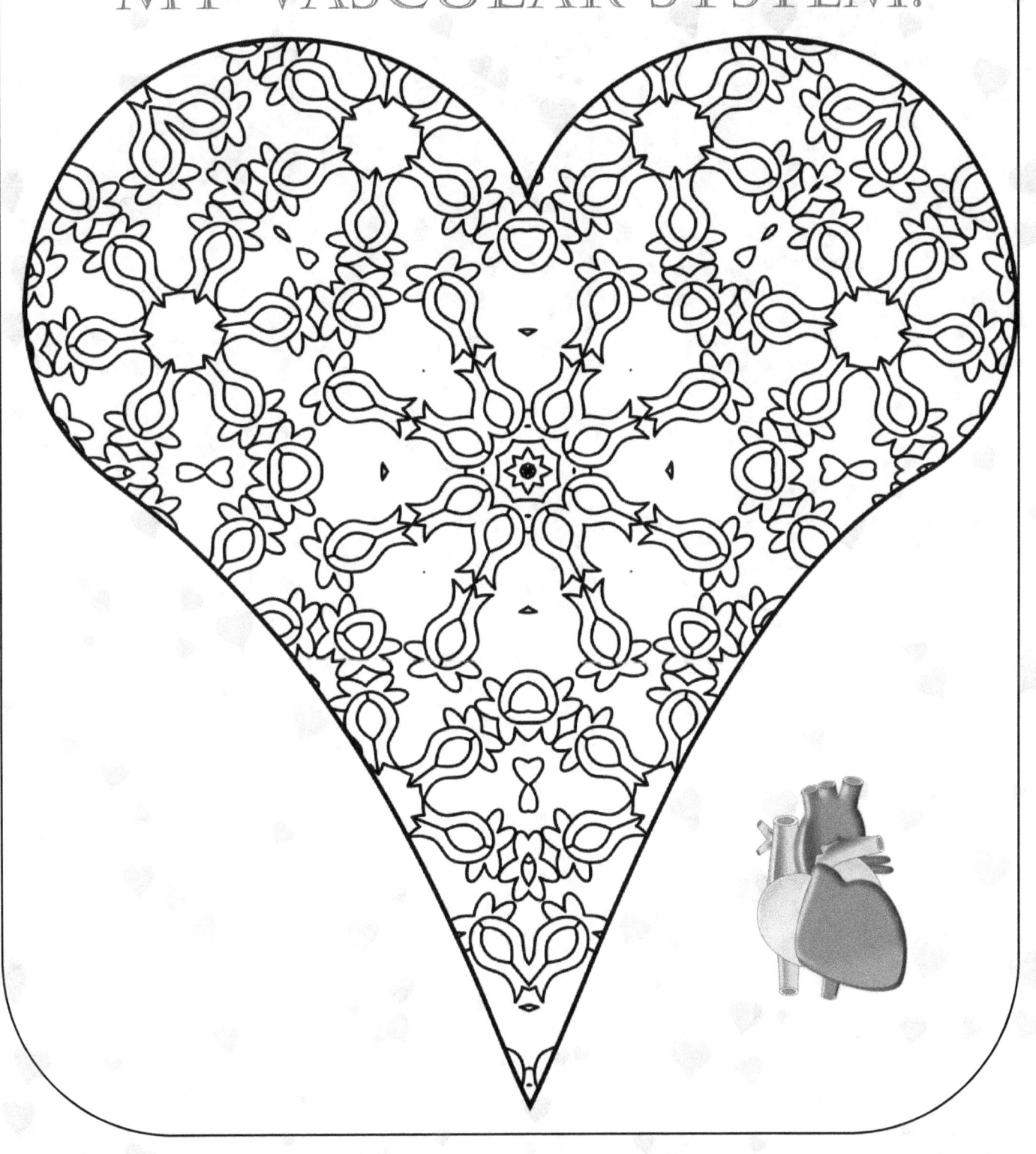

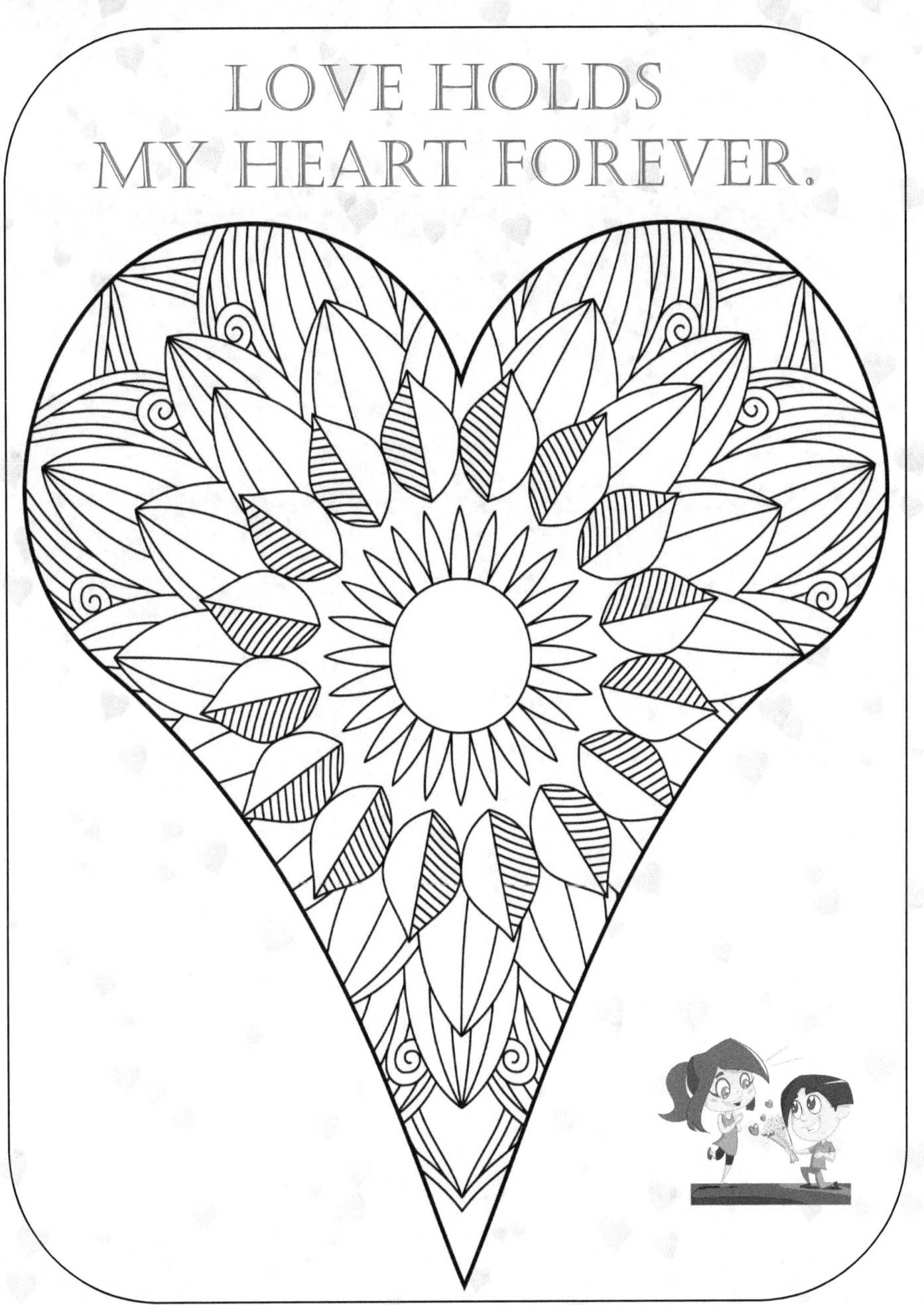

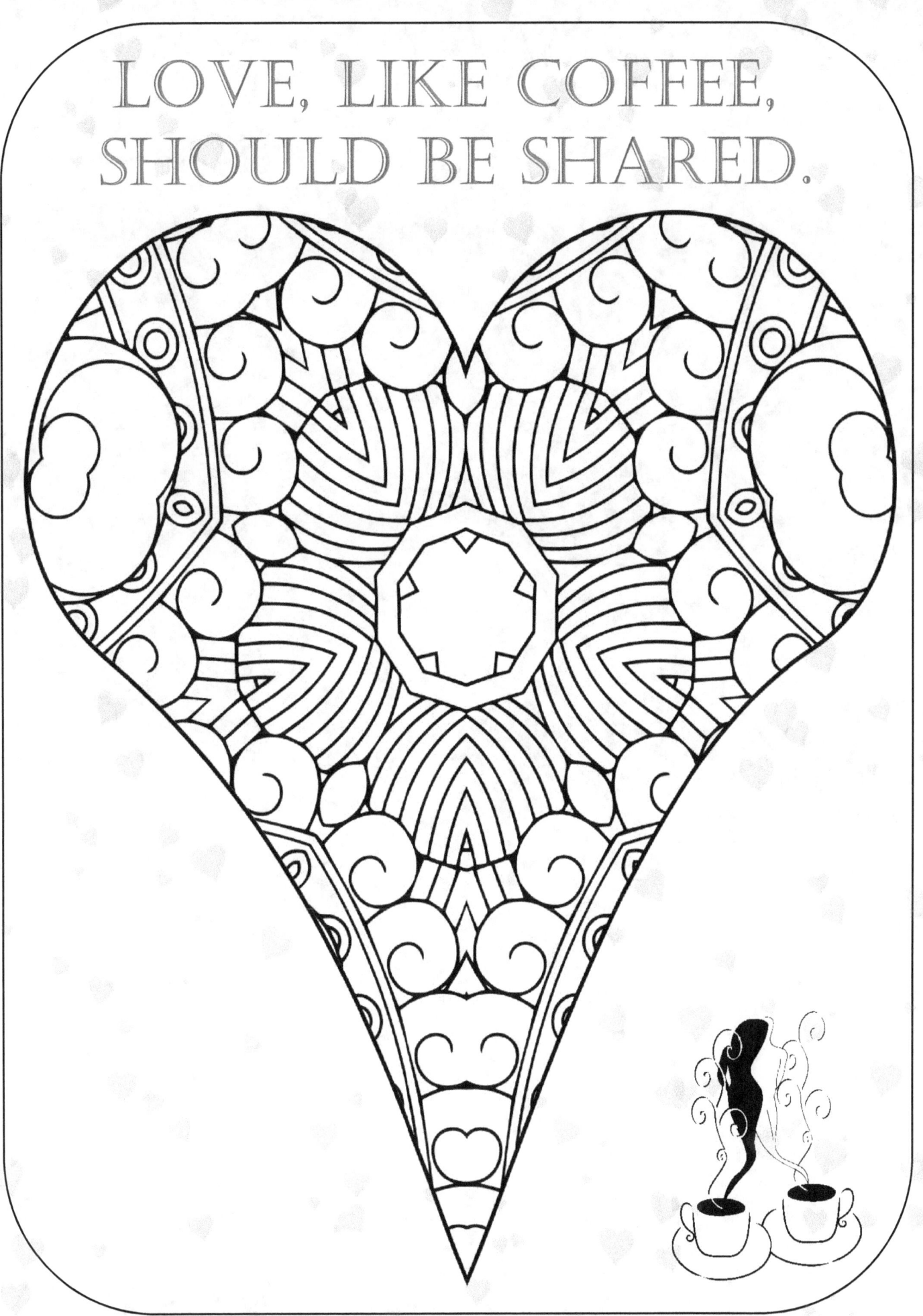

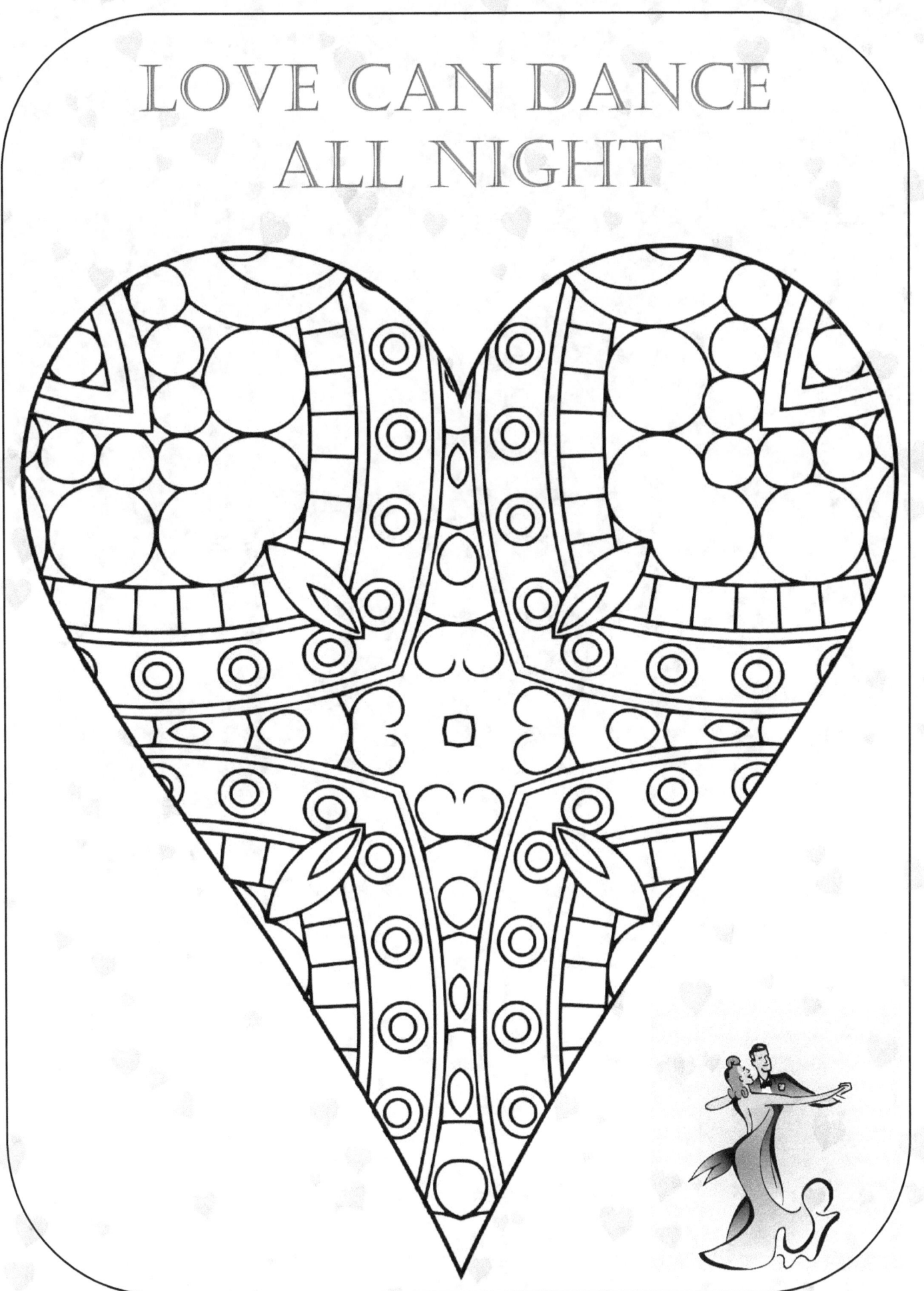

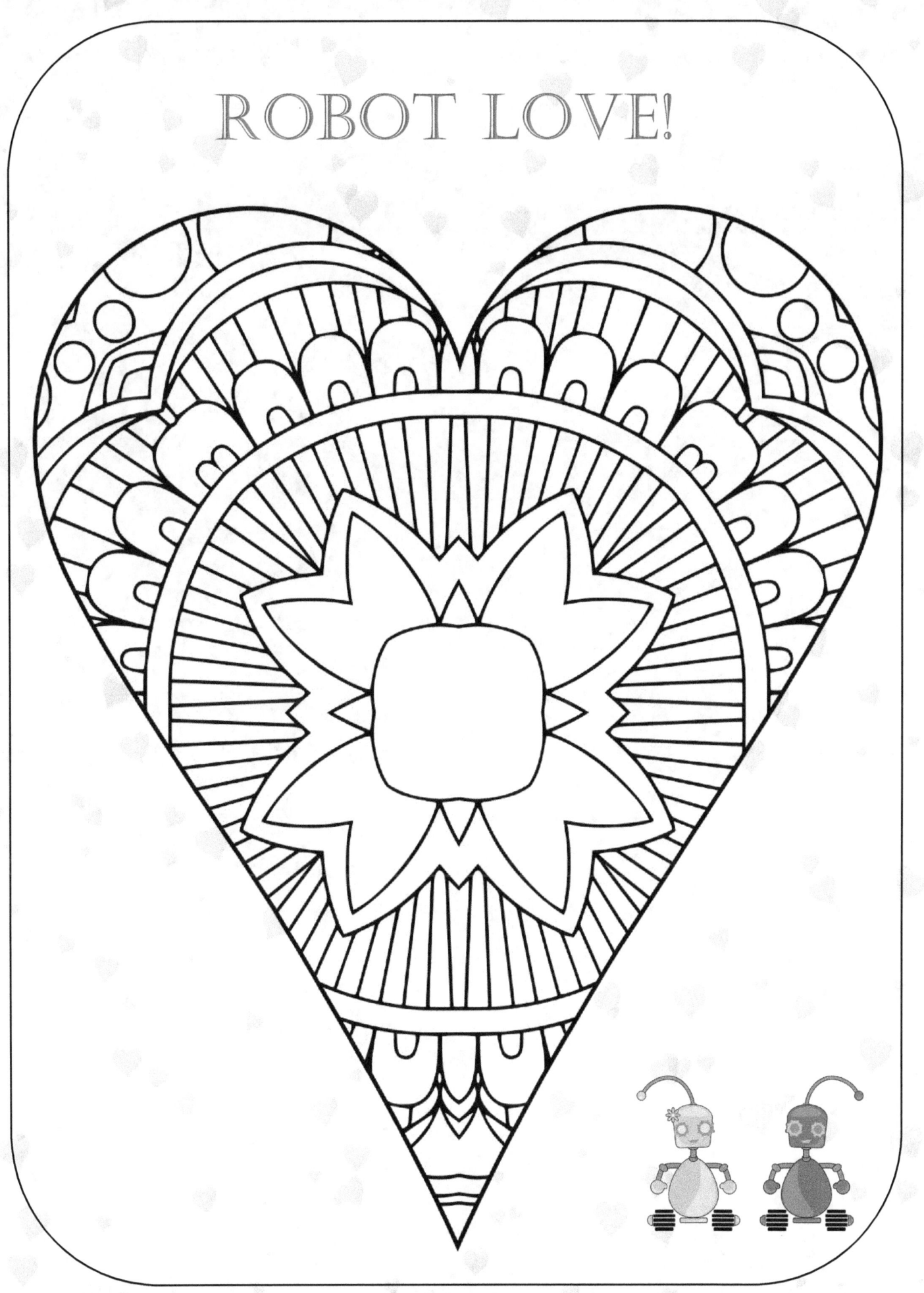

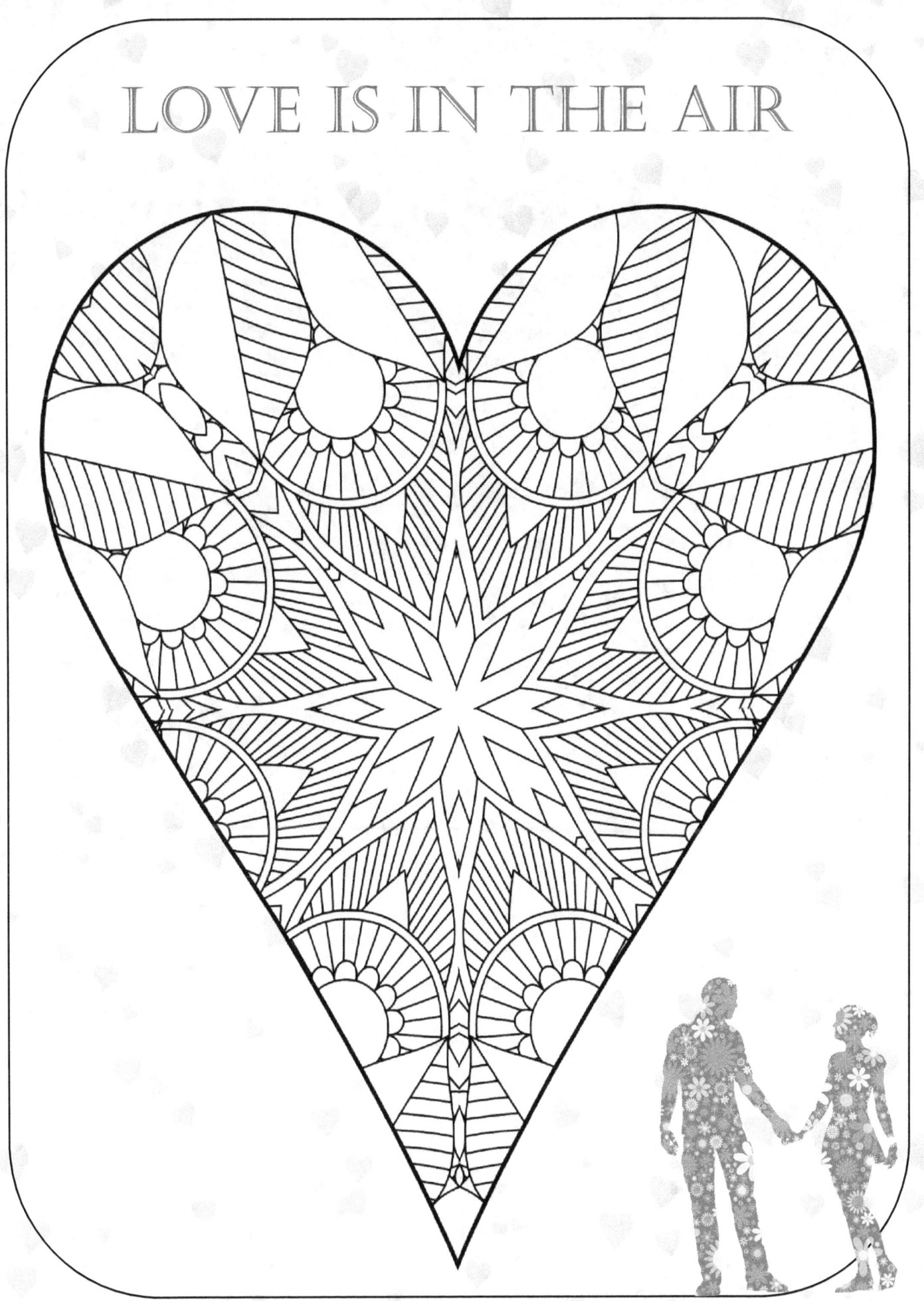

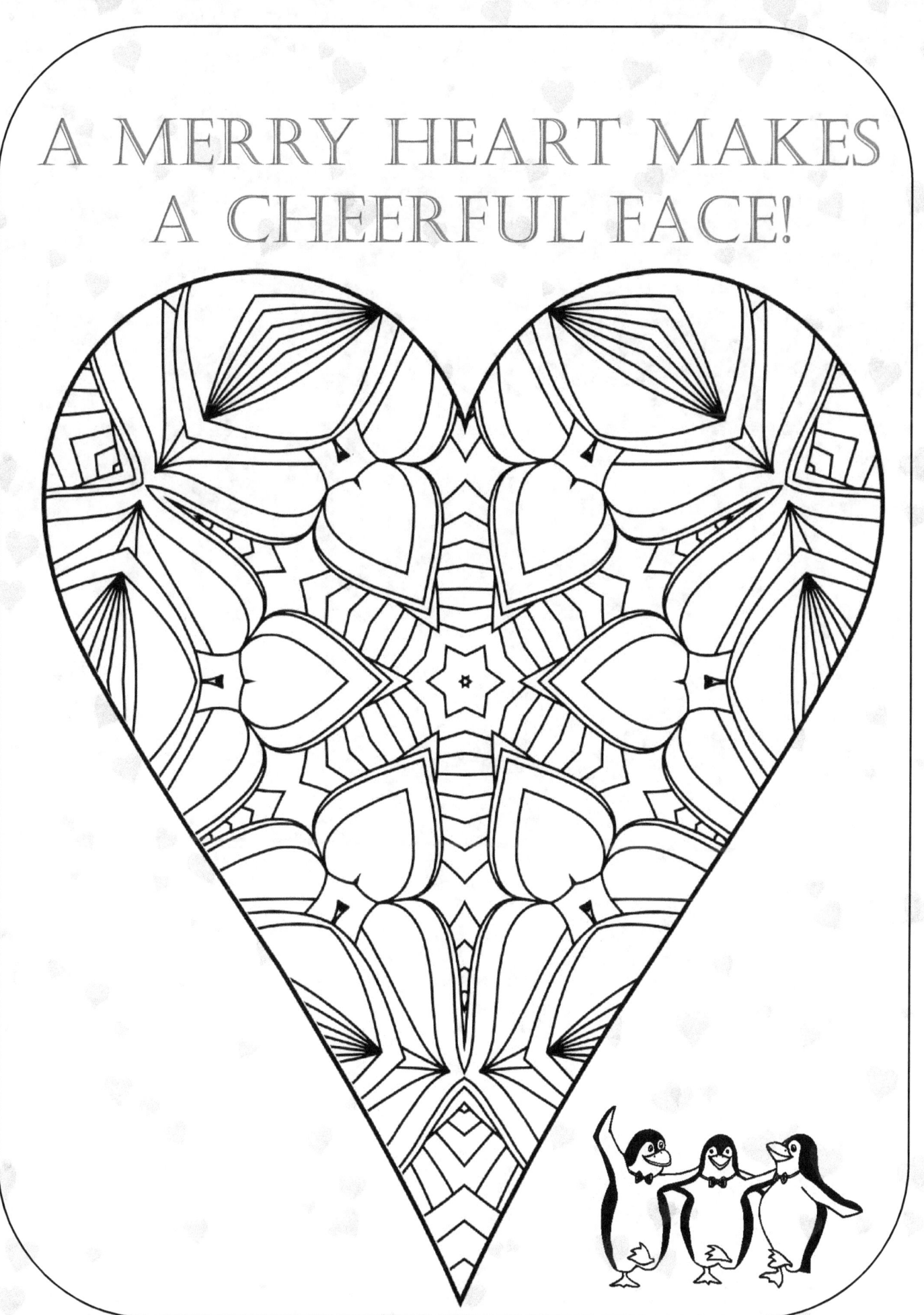

USE YOUR HEART TO CARE FOR OTHERS.

A GENTLE HEART IS TIED WITH A SINGLE THREAD

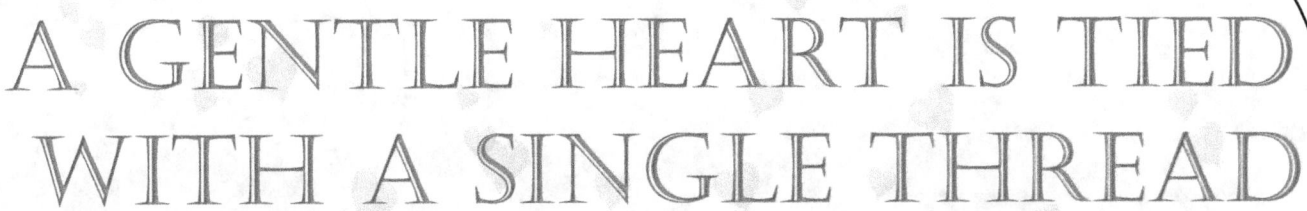

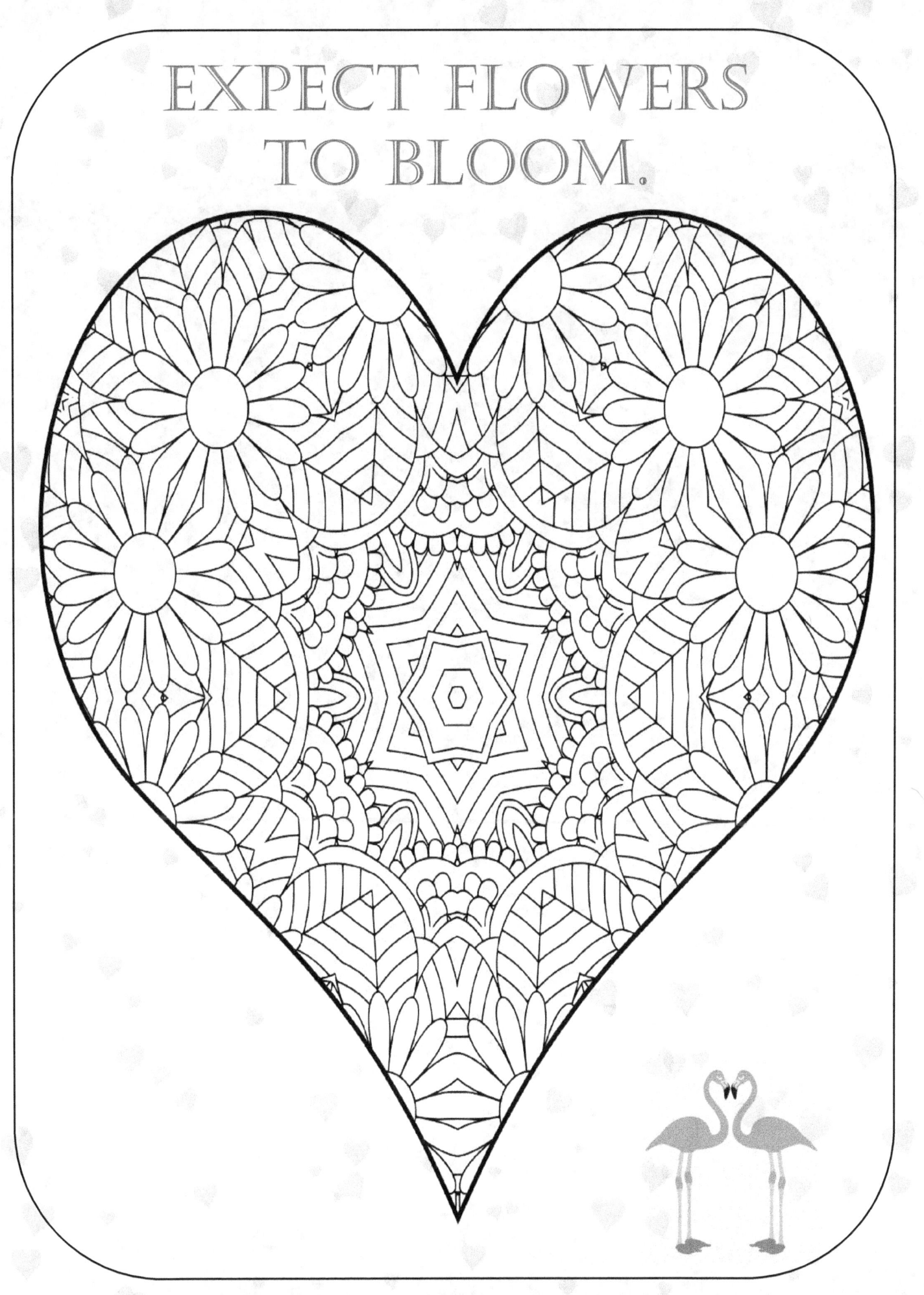

WRITE LOVE ON YOUR HEART.

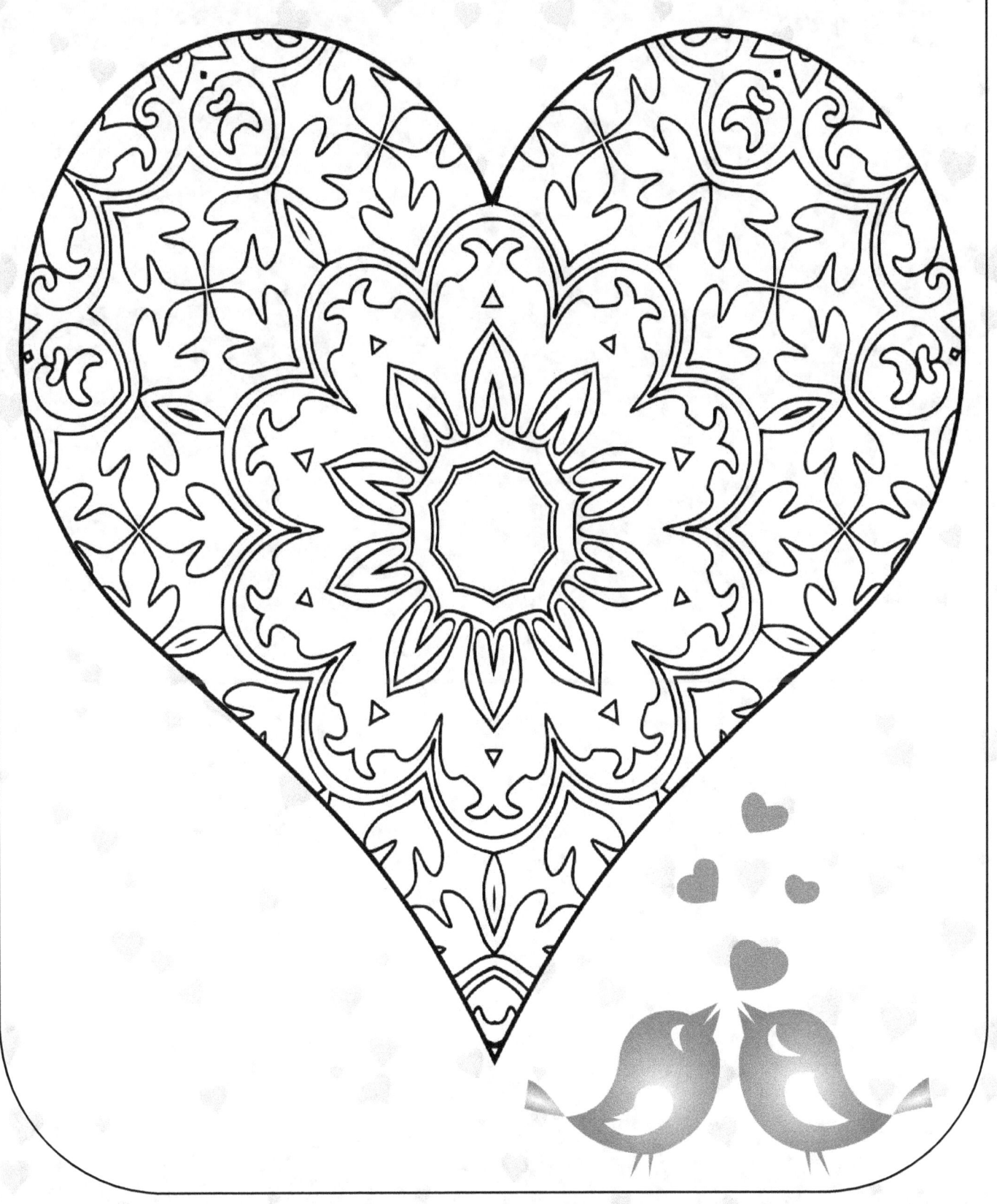

LOVE WITH ALL YOUR HEART.

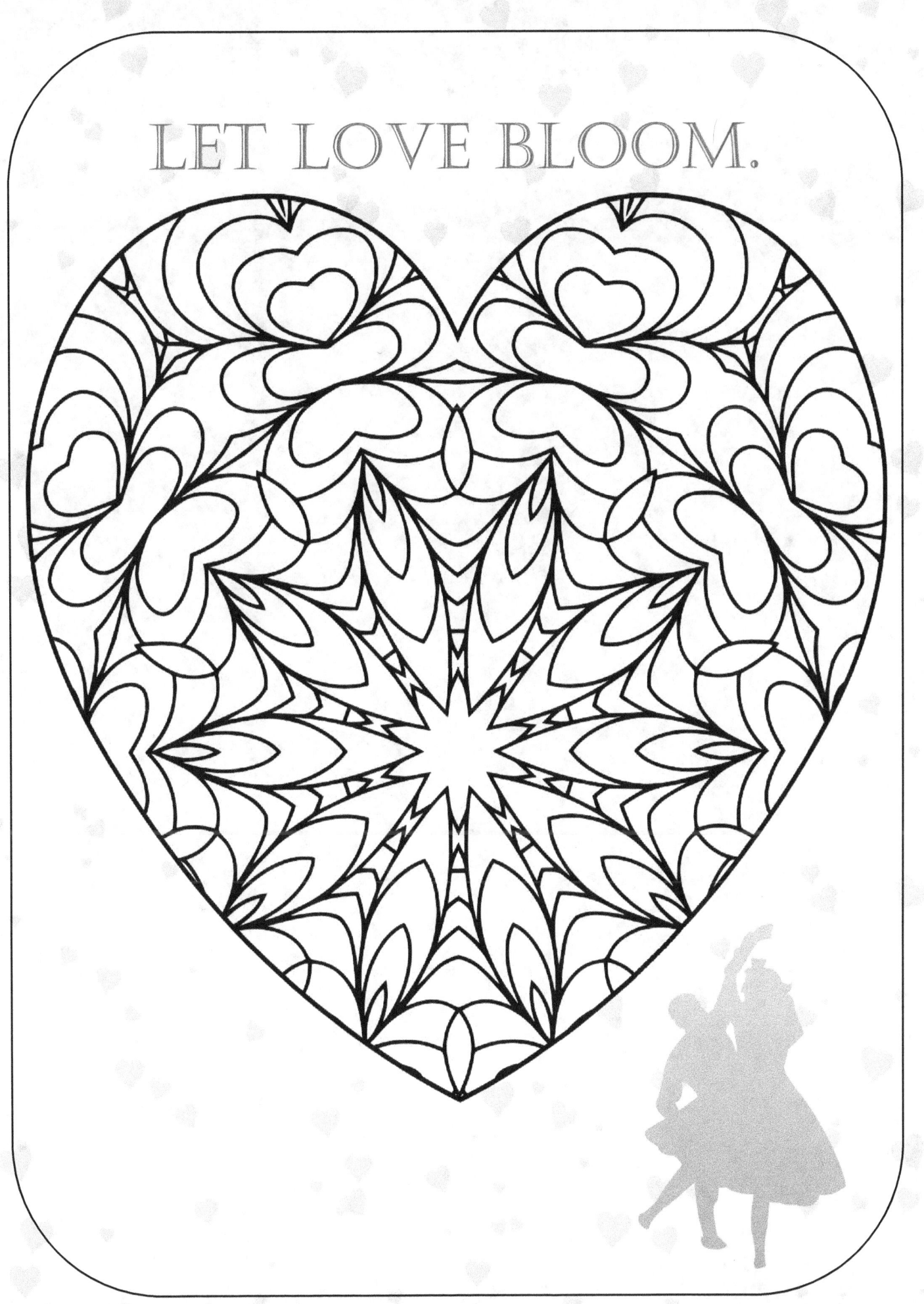

LET IT RAIN FLOWERS.

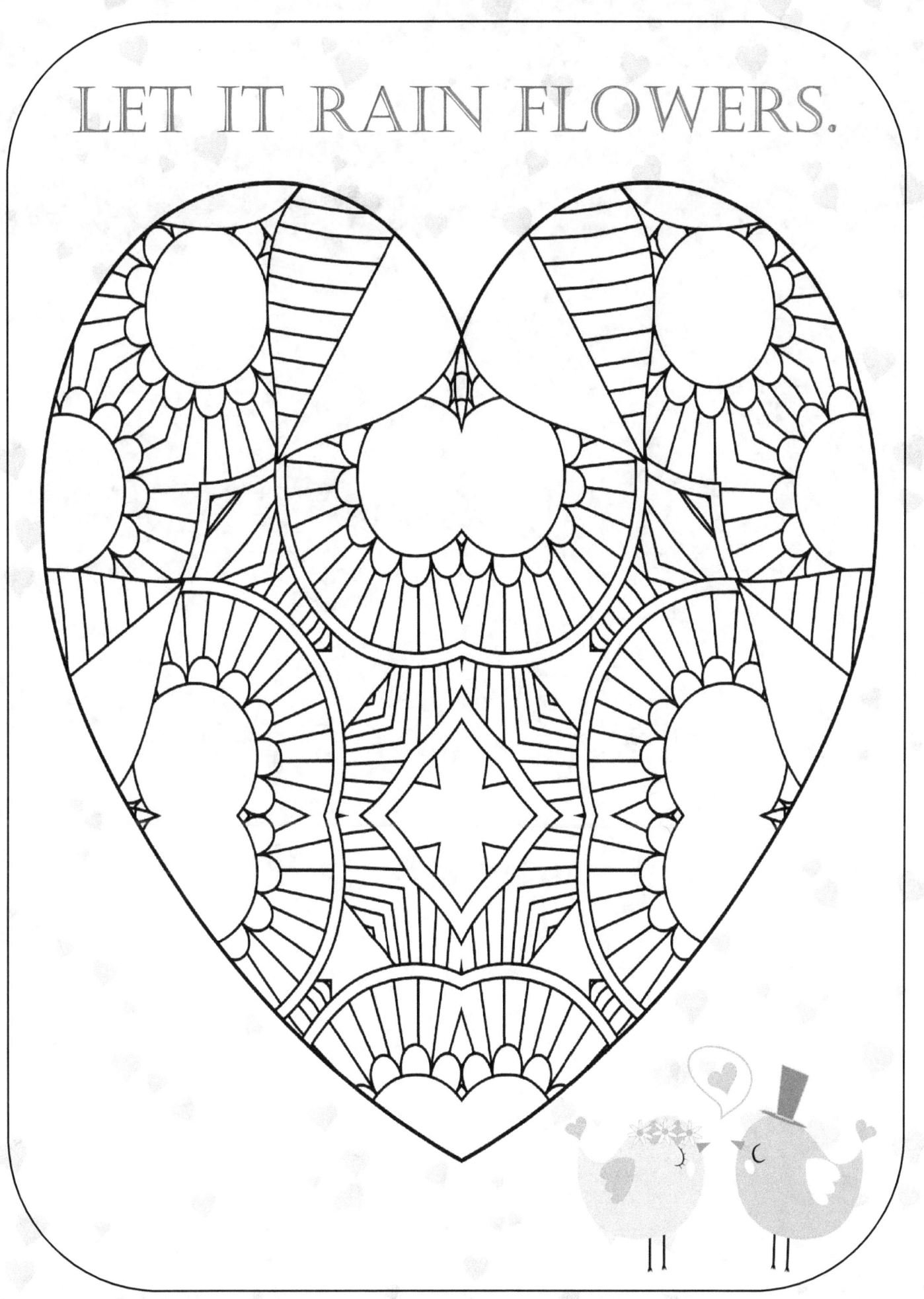

A FRIEND IS WHAT THE HEART NEEDS ALL THE TIME.

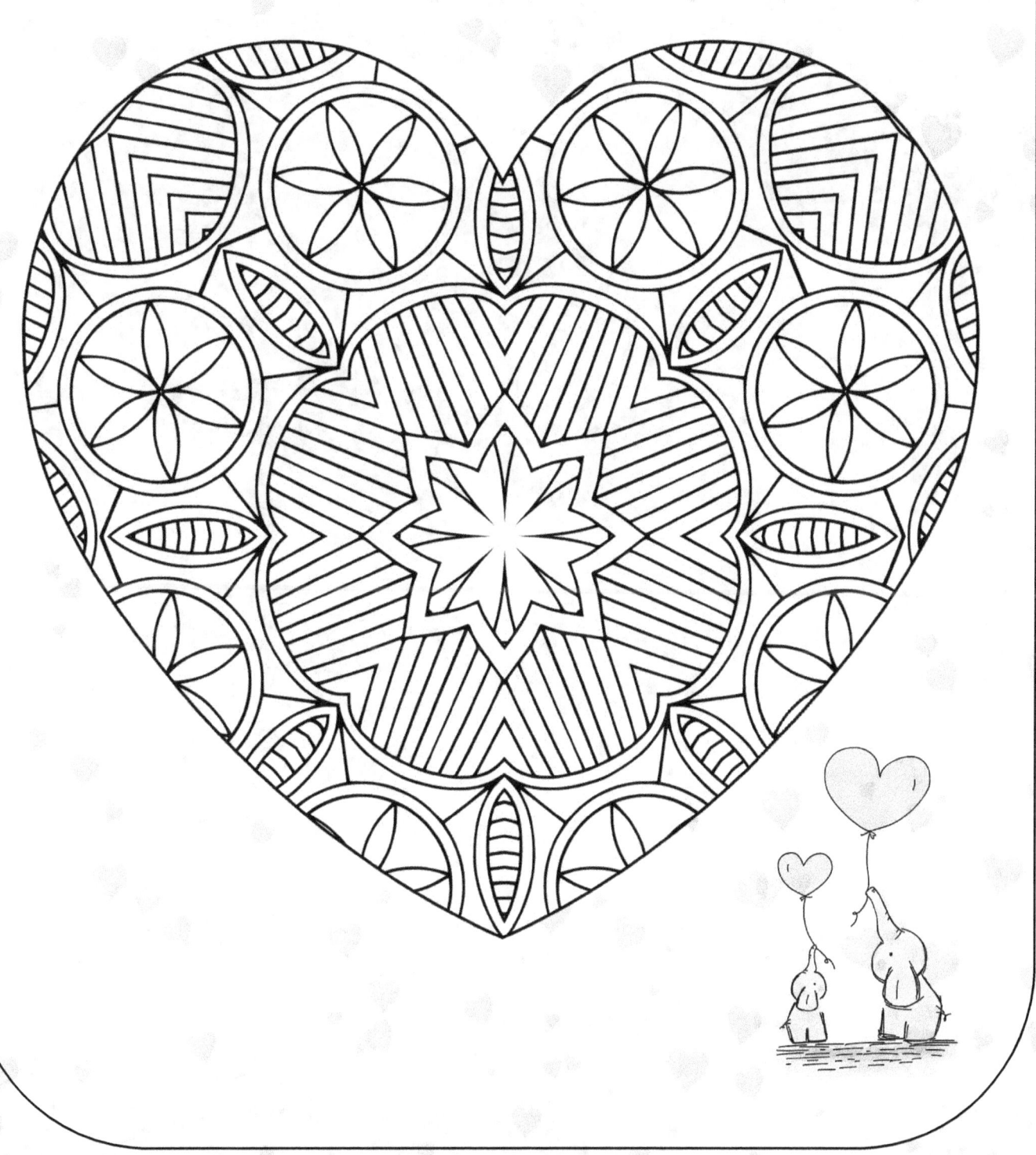

A LOVING HEART IS THE TRUEST WISDOM.